No part of this book may be
reproduced, stored in a retrieval
system or transmitted
by any mean without the
written permission
of the author

Published by Creative space 1/29/2016

Register at the library of congress
copy right #VAUI-024-810-2007
Creative space ISBN #
ISBN-13:978-1522 934325
ISBN - 10:1522934324

In Memory of

HELEN HOOVEN SANTMYER

"...AND LADIES OF THE CLUB"

INTRODUCTION

Now you must be asking yourself "what is a woodshed?" Let me tell you. A woodshed was used in the 1800's and the early 1900's. Woodshed's would keep the wood and tool s dry in the winter time. Wood was used to heat house s and cook the food in those day s. Today we use gas and electricity. In the future we will use solar and wind power the same way. So let get started and have some fun in the Woodshed with his friends. Mr. Wheelbarrow, Mr. Grindstone, & Miss Saw~Horse, And Mr. Saw.

Mr. Wheelbarrow Squeaks, poor Wheelbarrow is so old its bones ache. It say 'Oh, oh, oh! I'm not so spry as I used to be, Oh, oh, oh!' Then it goes along muttering to itself the way old people do Time I was left to take my ease in the woodshed. I've done my share of work in the yard.

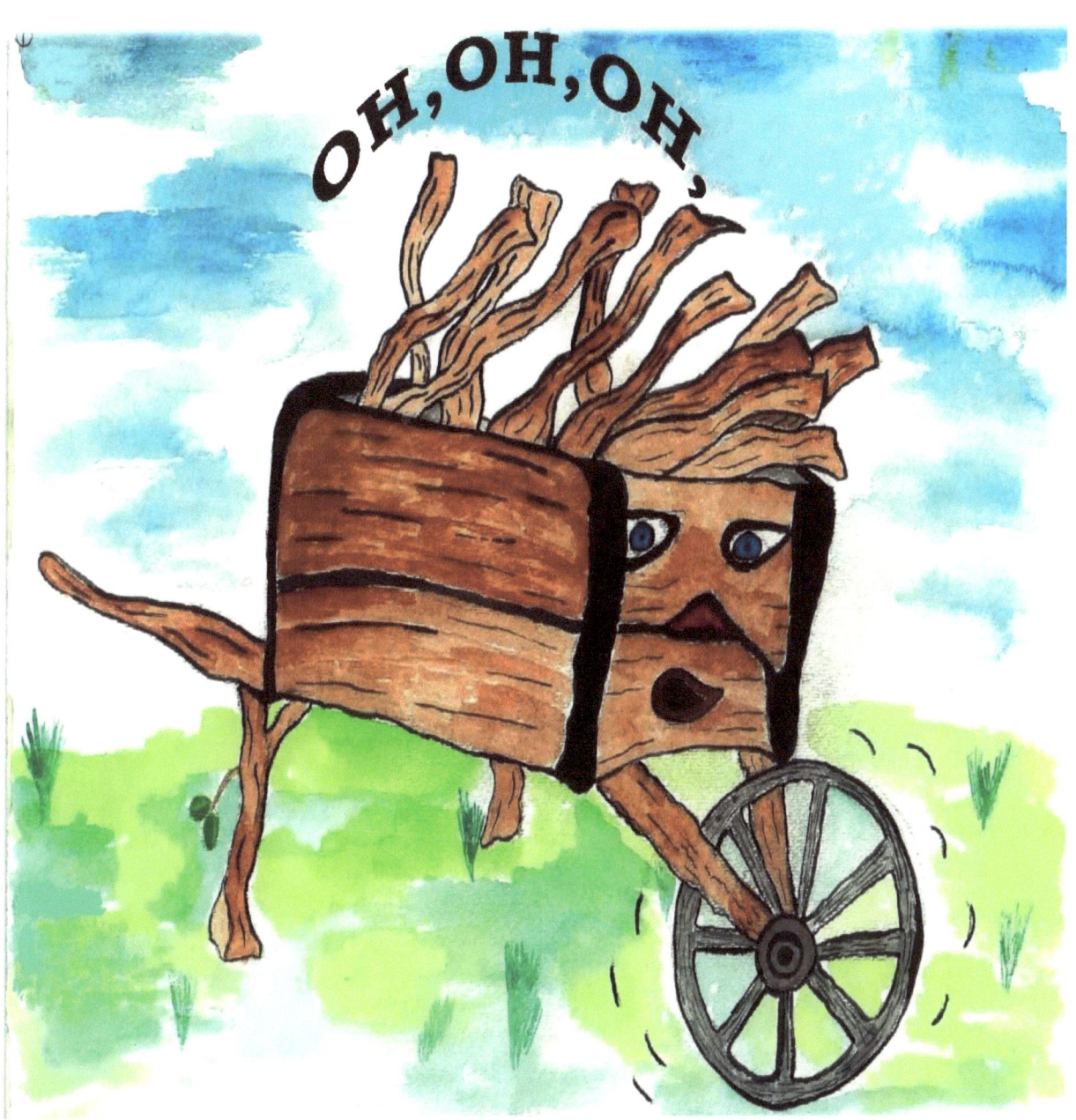

That Mr. Grindstone, now, he has all the luck~ he doesn't have to go trundling about the world this way!' And so on, grumble, grumble, whine, whine. Maybe if Mr. Wheelbarrow has a good drink of oil he would feel better.

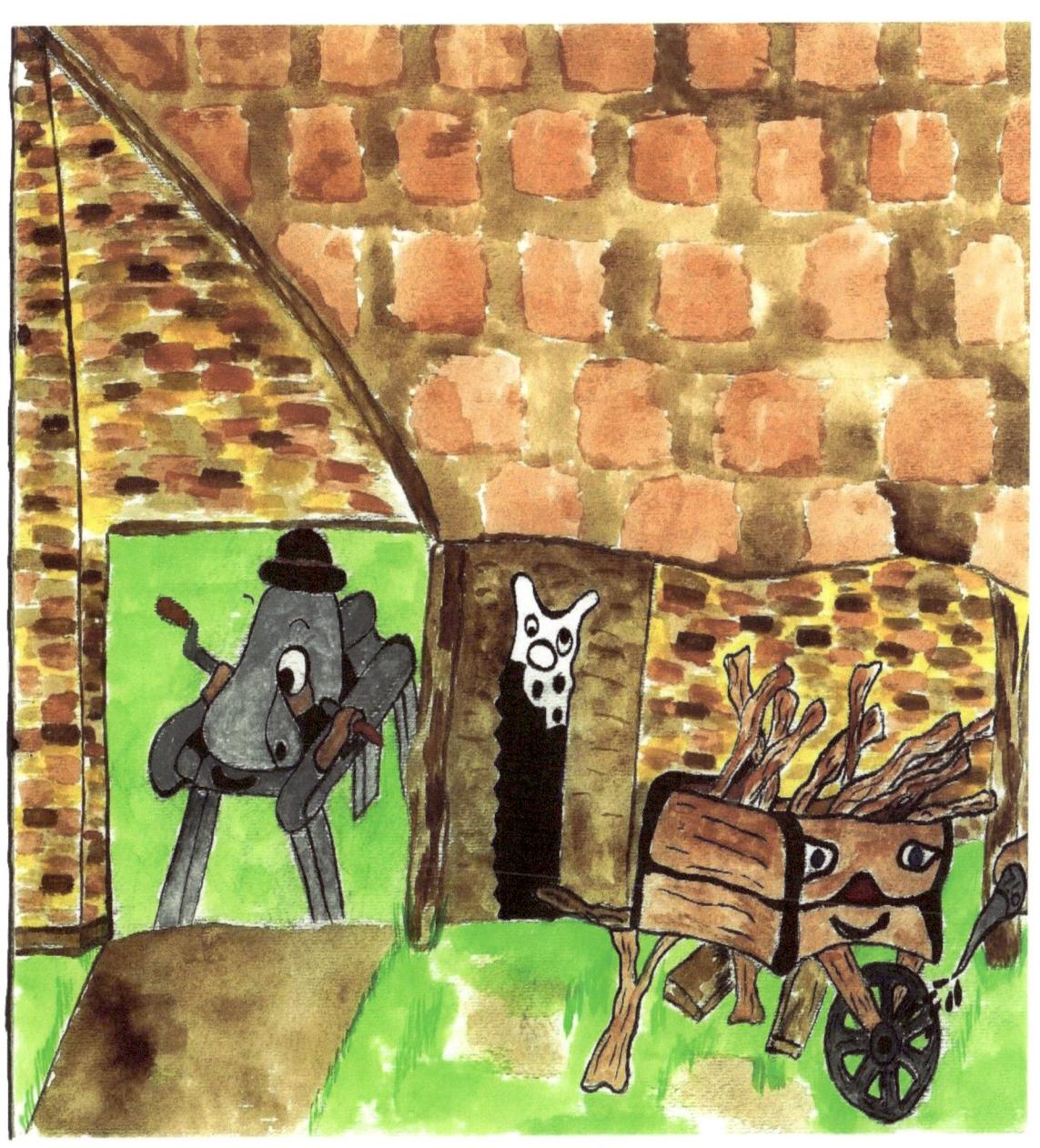

What does Mr. Grindstone say?
Let me turn for a while this morning
when he was sharpening the sickle.

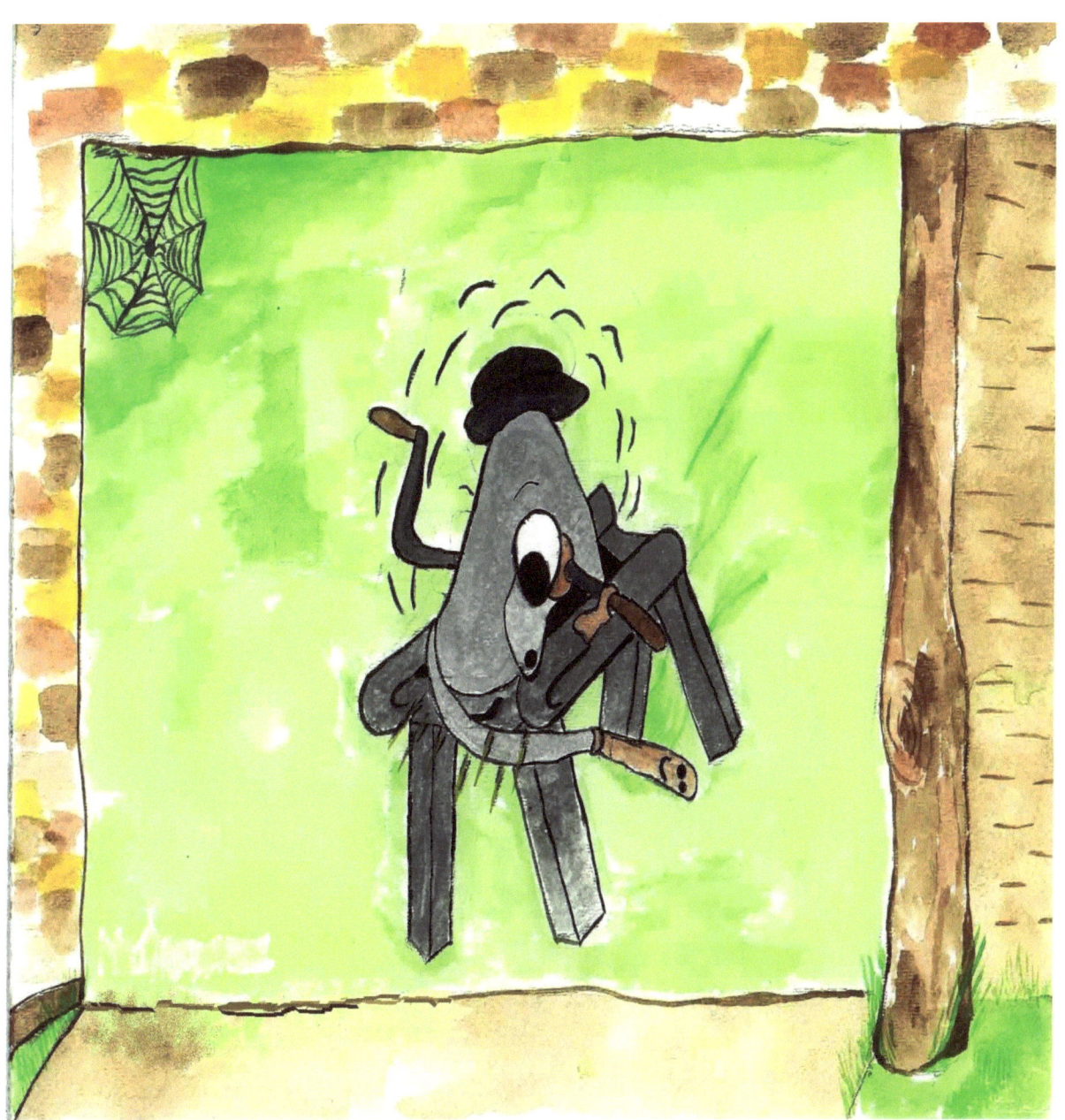

His nose twitched, He loved the woodshed: its rotten-wood smell, the cobwebs, all the saw hanging on the wall, the little square window that wouldn't open because of the trumpet vine growing thickly over it, making a dim green light inside unless you left the door ajar.

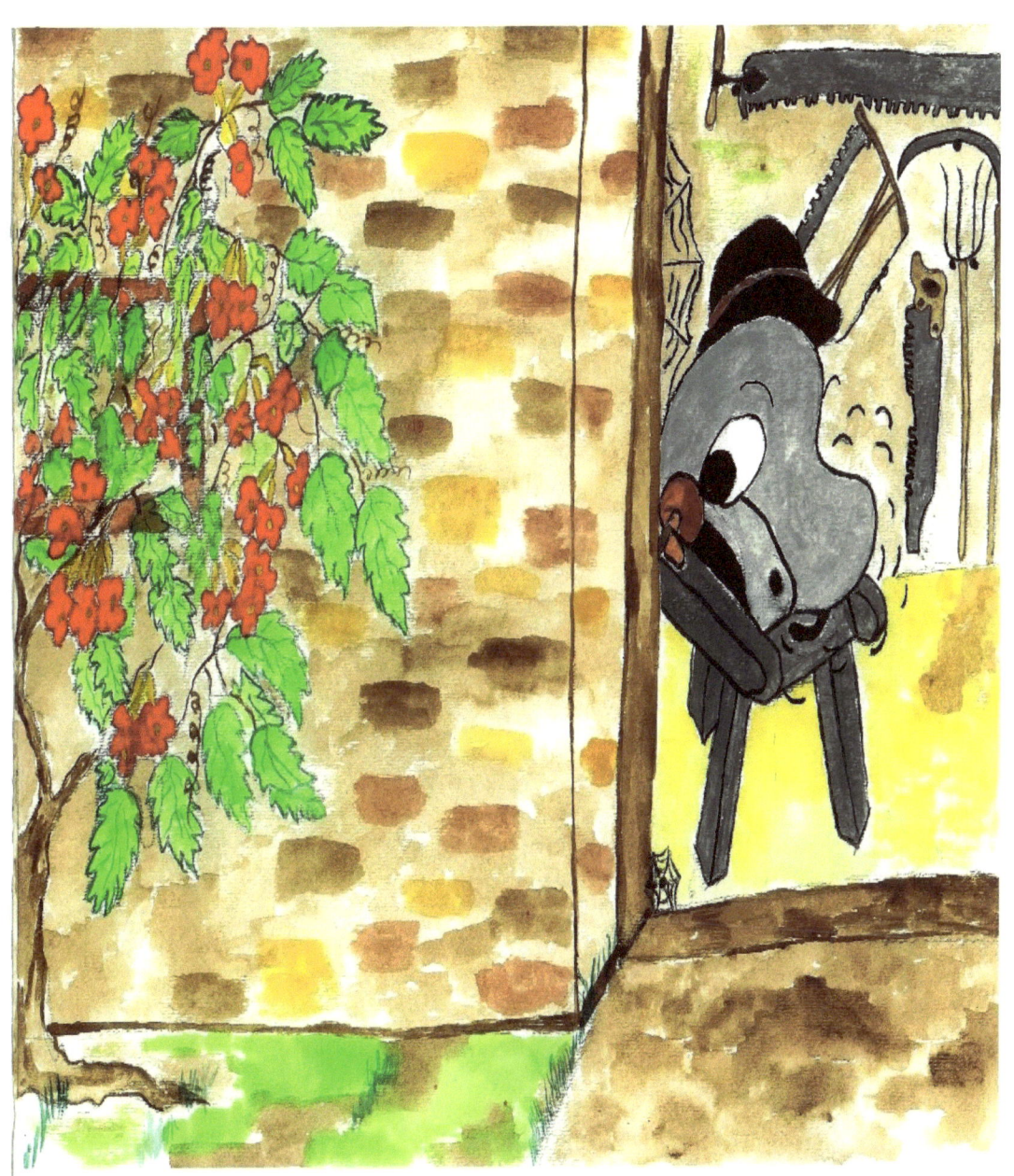

"Well, what did he say, then? You heard him. Did he grumble?" He didn't like it very well, I guess, that he only get's drinks of water when Mr. Wheelbarrow gets oil.

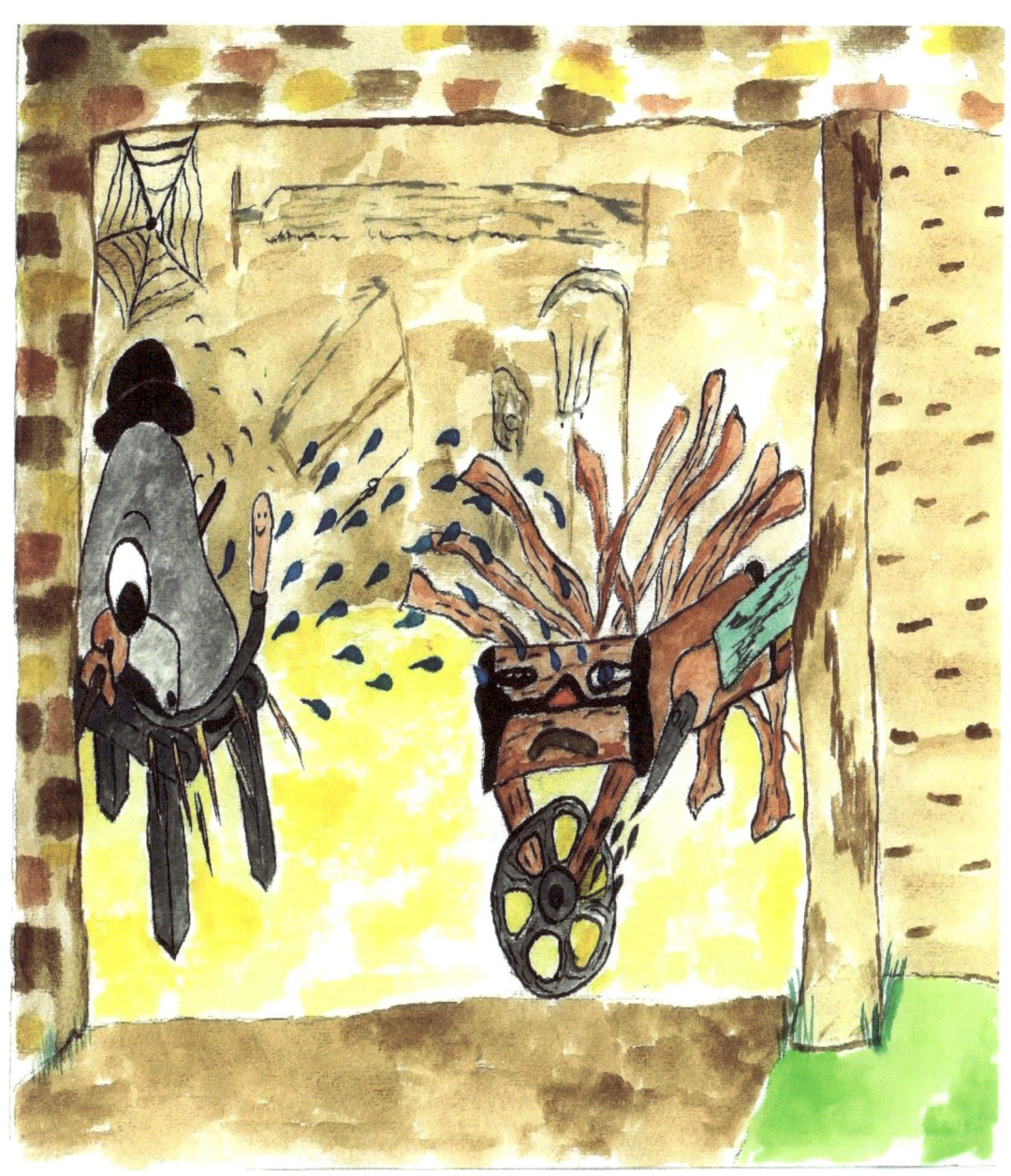

Mr. Grinstone say Whats~s~s this ~s~s?

S~s~s~ sickles for the grass~s~s.

I like to be the sickle, out in the s~s~ sun.

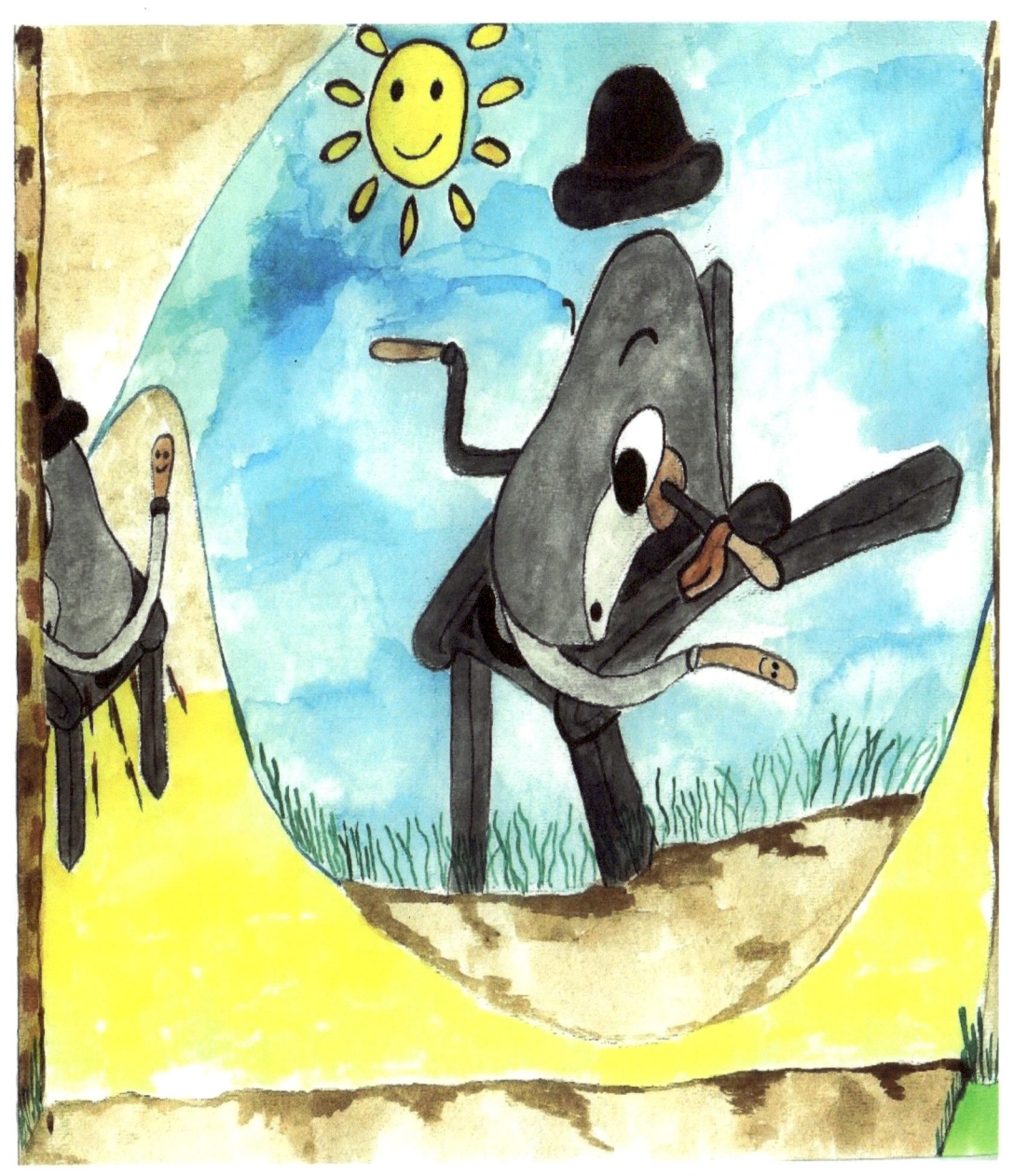

Here I s~s~sit in the woods ~s~ shed, doing my work in the dark. And Mr. Wheelbarrow has all the fun out in the world every day!"

It's really very silly for them to call each other 'Mr.' they've been neighbors in the woodshed for so long.

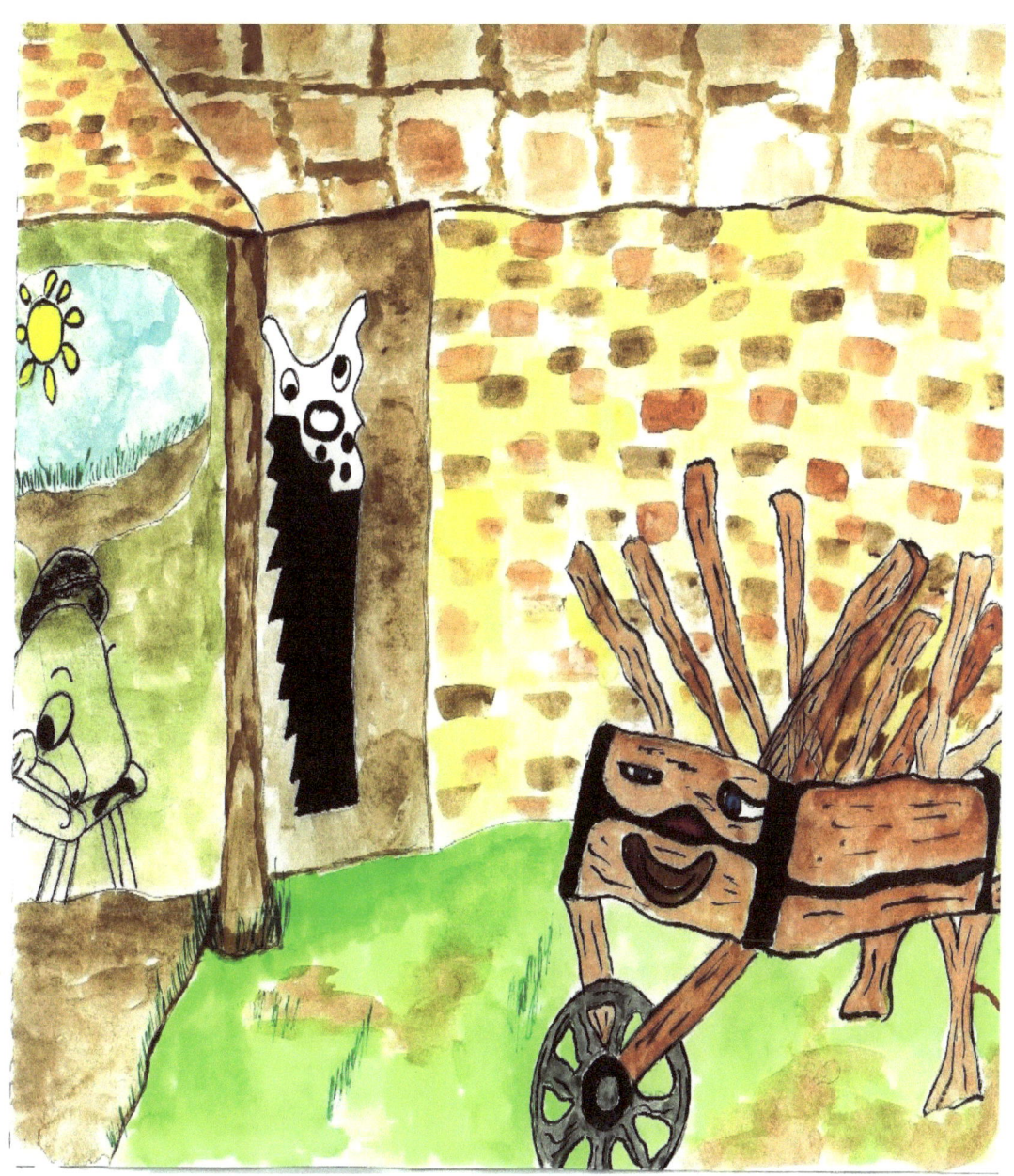

But they had a falling out long ago when they were both in love with Miss Saw-Horse, and they've said 'Mr.' ever since, though once upon a time, when Mr. Wheelbarrow was young, they were friends.

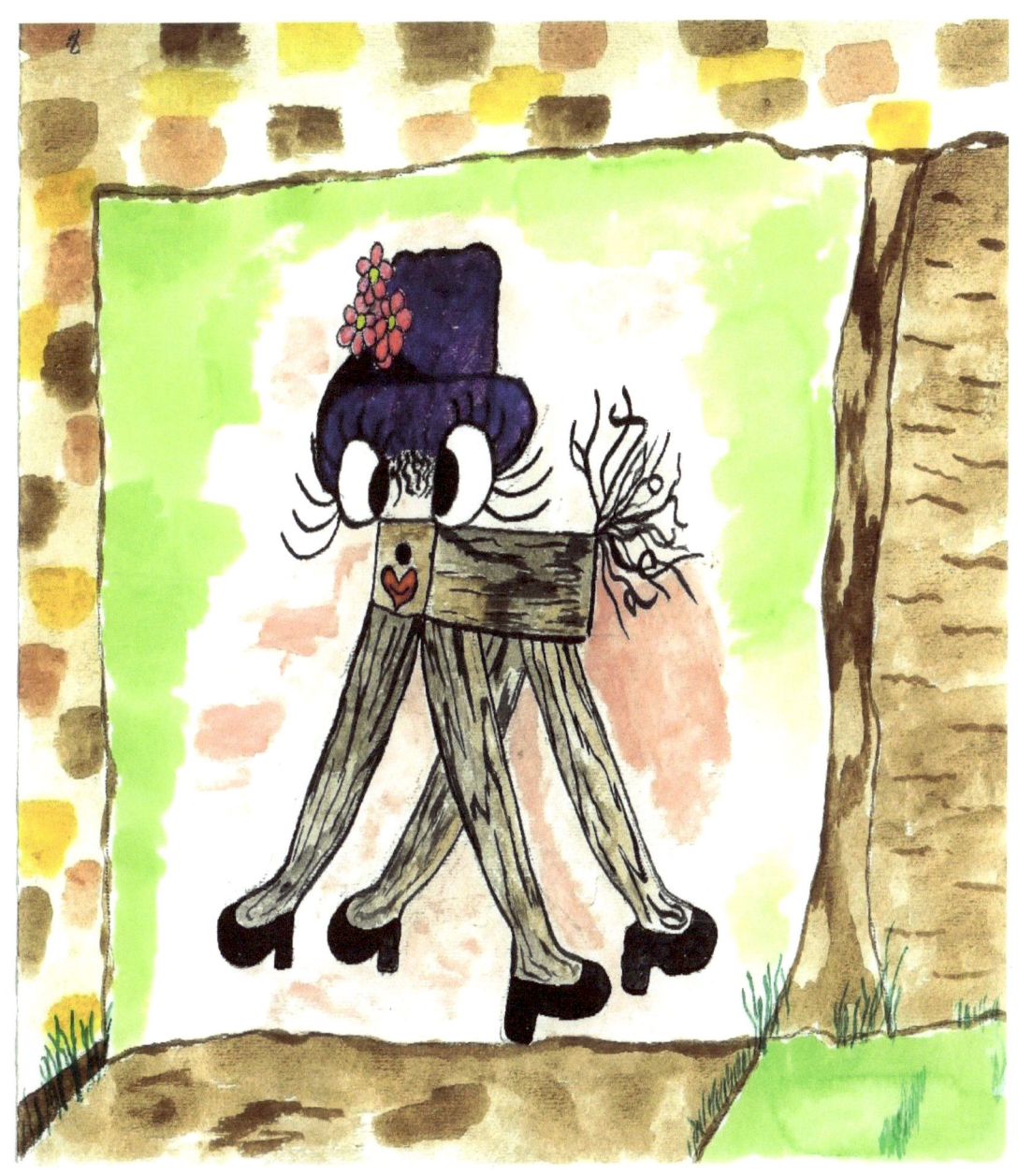

"Wasn't Mr. Grindstone young, too?"
Oh, he's much, much older then Mr. Wheelbarrow, really, but he doesn't show his age.

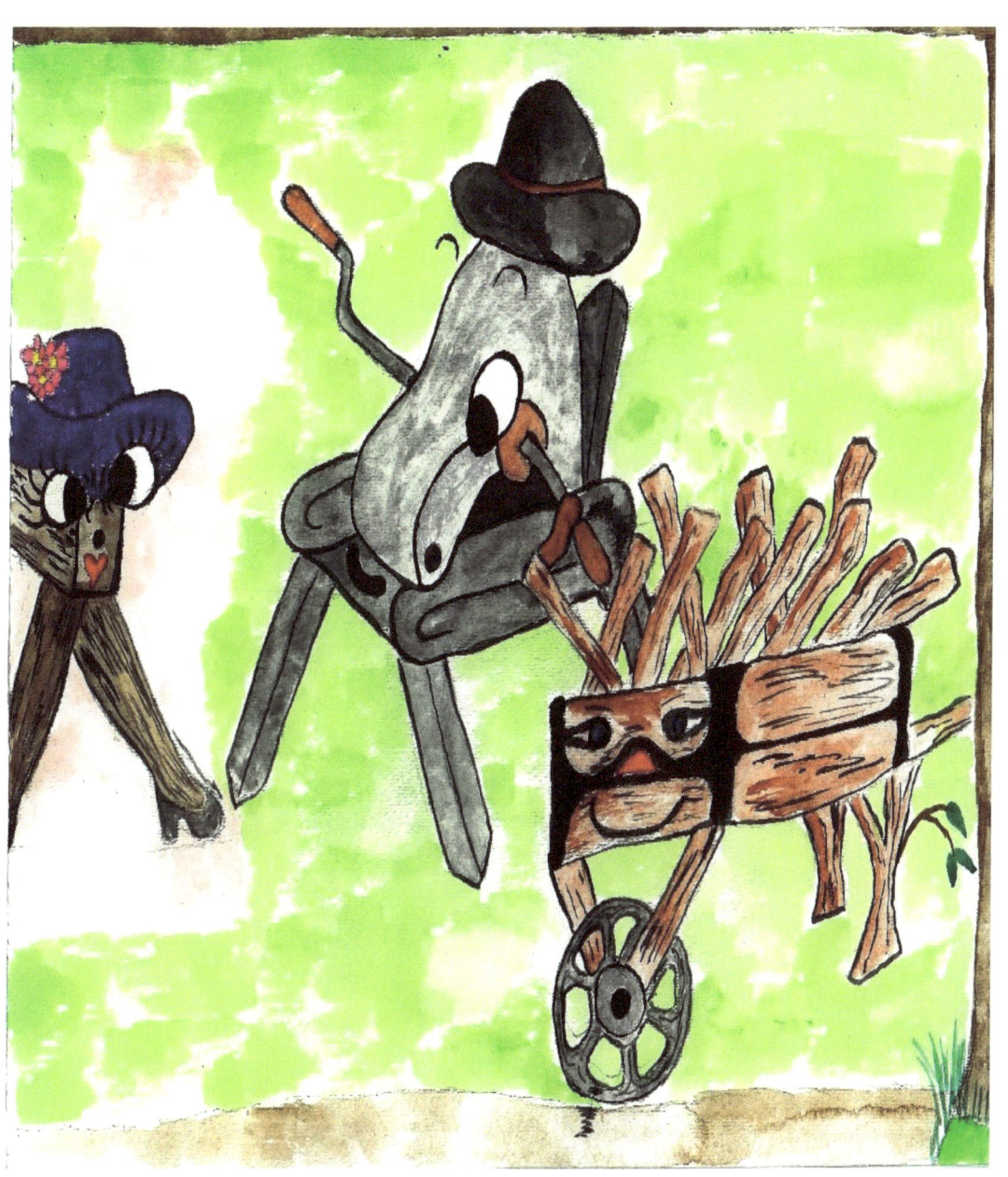

He's too old for Miss Saw-horse but he didn't think so himself, naturally and he used to be quite angry when Mr. Wheelbarrow managed to get put on her side of the woodshed. Mr. Wheelbarrow would come in from the yard saying, 'Please put me in the corner!' You see, he squeaked in those days, too, but he didn't grumble, and whoever had a hold of him put him down quick to stop the squeaks.

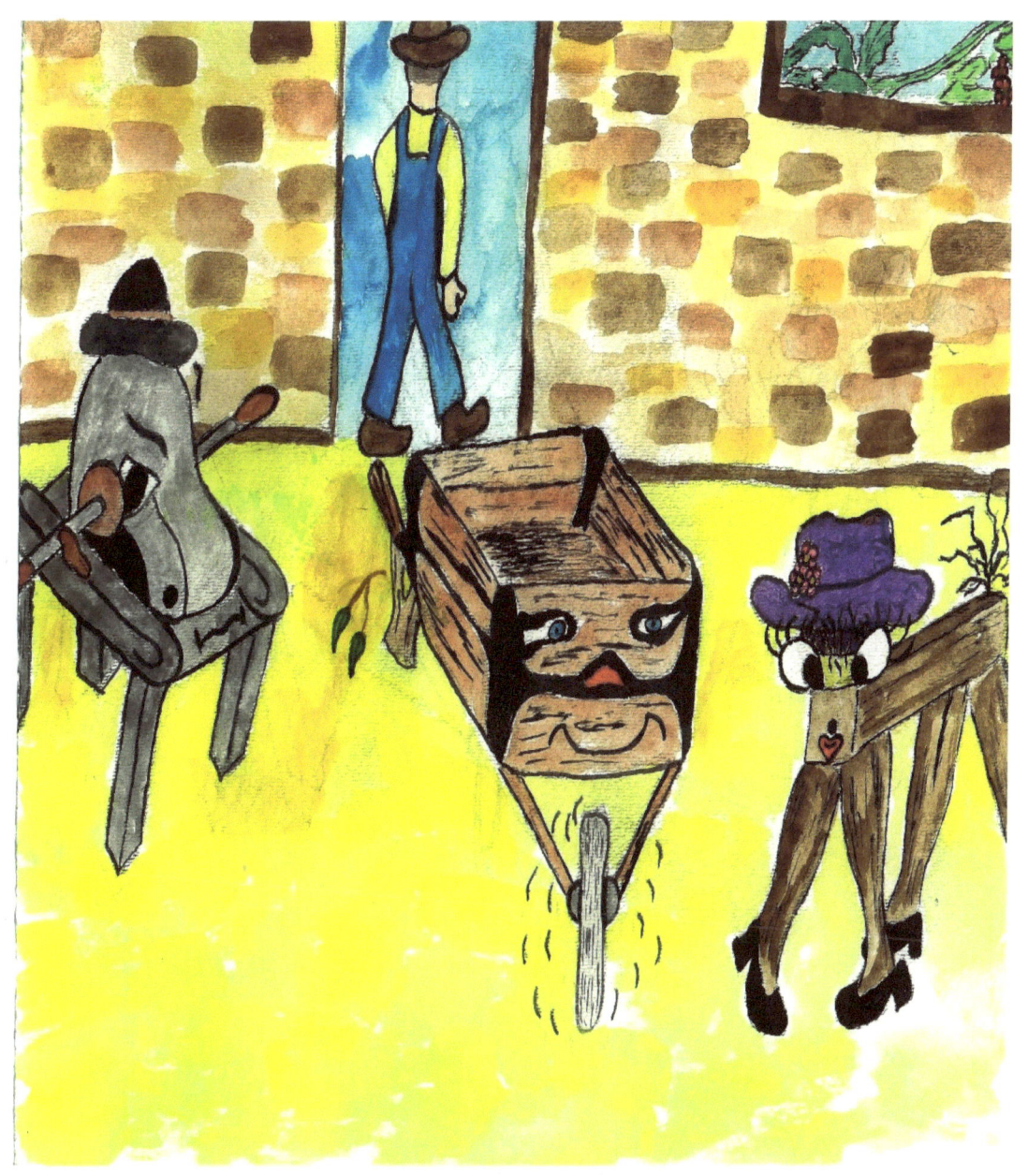

AND THAT WOULD
LEAVE MR. WHEELBARROW
CLOSE TO MISS. SAW-HORSE,
AND ALL NIGHT LONG THEY
COULD LOOK OUT THE
WINDOW AND WATCH THE
STARS BETWEEN THE LEAVES
OF THE TRUMPET VONE

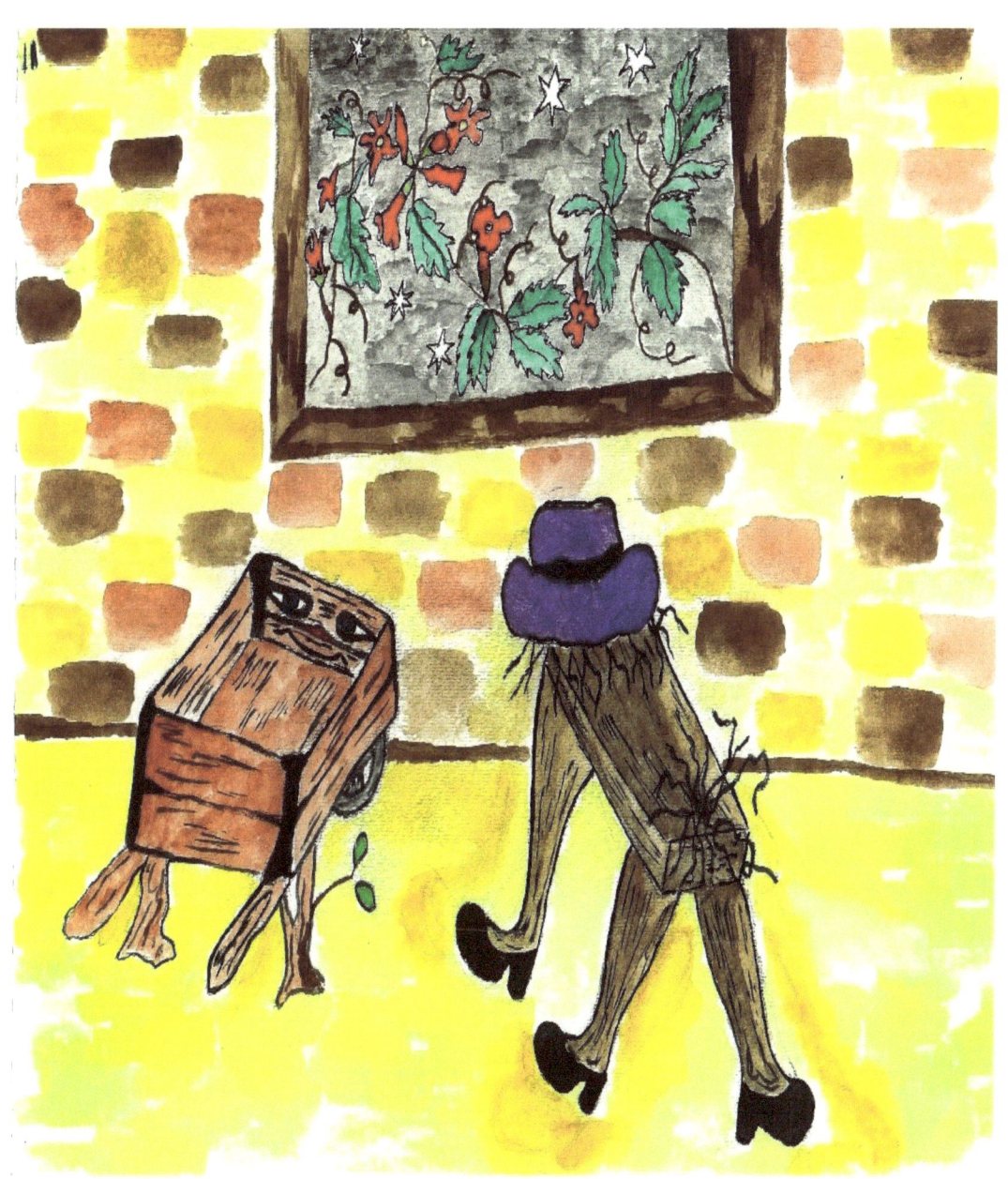

But in the morning Mr. Wheelbarrow would be taken out again, mad as hops because Mr. Grindstone would be left all day alone with Miss. Saw~Horse, and he wouldn't be able too hear a word they said.

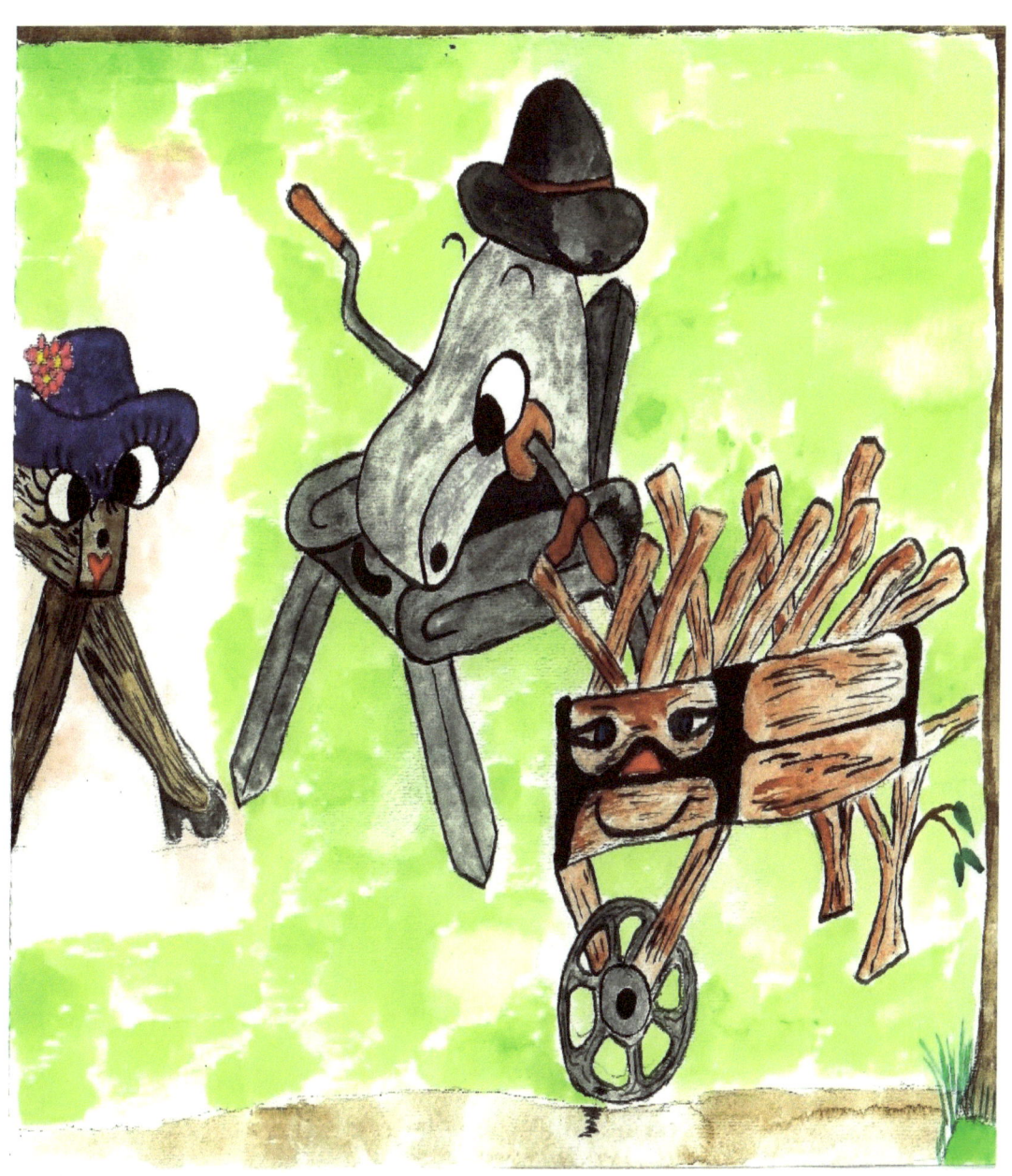

"Mr. Wheelbarrow and Mr. Grindstone both wanted to marry Miss. Saw~Horse once upon a time," "Indeed! And what has Mr. Saw to say to that?"

There isn't any Mr. Saw in the story or is there